Then & Now
Indianapolis

RALSTON'S PLOT. Alexander Ralston drew up the "Mile Square" plot of Indianapolis in 1821. At the center of the city plan was the Governor's Circle, now known as Monument Circle. The streets that bordered the plot were later named East, West, North, and South. At the time, the original planners didn't think that the city would get much bigger than what they planned.

Then & Now

INDIANAPOLIS

W.C. Madden

ARCADIA
PUBLISHING

Copyright © 2003 by W.C. Madden.
ISBN 978-0-7385-2344-6

Published by Arcadia Publishing
Charleston SC, Chicago IL, Portsmouth NH, San Francisco CA

Printed in the United States of America

Library of Congress Catalog Card Number: 2003105615

For all general information contact Arcadia Publishing at:
Telephone 843-853-2070
Fax 843-853-0044
E-Mail sales@arcadiapublishing.com

For customer service and orders:
Toll-Free 1-888-313-2665

Visit us on the Internet at www.arcadiapublishing.com

CONTENTS

Acknowledgements 6

Introduction 7

1. Streets 9

2. Government 25

3. Business, Buildings, and Bridges 37

4. Homes and Divisions 67

5. Parks, Monuments, and Others 83

Acknowledgments

While I was working on *Indianapolis in Vintage Postcards* (Arcadia, 2002), I came across a man by the name of George Mitchell, who possessed some 7,000 postcards of Indianapolis. I also found out that he had a collection of old photos of Indianapolis. The exact date of the photos or the photographer was unknown to him. He didn't think they came from Bass Photography, who gave a large collection of photos to the Indiana Historical Society. Bass photos were not selected for this book due to the high cost of reproduction by the IHS. Many of the historical photos in this book come from Mitchell's collection of photos and postcards. I am indebted to George for his invaluable assistance for this book. Also, thanks to Sally Cook, James Hendrix, and others who provided information for this book.

Introduction

Indianapolis was born when Congress adopted a resolution donating four sections of land to the state on which to establish its capital. This occurred when Indiana was admitted to the Union in 1816. The location was chosen because the west fork of the White River was the only navigable stream in the central part of the state.

After careful consideration of three points along the White River, the mouth of Fall Creek was chosen. The river banks afforded a good boat landing, and there was high and level ground for the city. At the time, the National Road was south of Indianapolis, but a bridge over White River at Indianapolis soon changed the course of the road so that it passed through the city.

The name of the city also underwent careful consideration. Some wanted "Tecumseh" after the Indian chief located in Indiana. Others liked "Suwarrow," a high-sounding European name. In the end, "Indianapolis," which Judge Jeremiah Sullivan suggested, was decided upon—Indiana after the state and "polis" from the Greek word for city.

The first settlers to the area came around 1820 and included the Pogues, McCormicks, Maxwells, Barnhills, and the Wilsons. Isaac Wilson built his first house on what is now the State House block. George Pogue built his cabin on what is now 420 Highland Avenue on the near east side of Indianapolis. A year later, the city was platted by Alexander Ralston and Elias Pym Fordham. Ralston, who assisted in laying out Washington D.C., gave Indianapolis a similar treatment to the nation's capital and laid it out in a mile square. In the center of the plat was the Governor's Circle, now Monument Circle. After the land was platted, lots were sold. The highest plot went for $560 and was located at the northwest corner of Delaware and Washington Streets. The next highest was $500 at the northwest corner of Senate and Washington Streets, which now belongs to the state. The lots along Washington Street sold for $200-300. In all, 314 lots were sold for a total of $35,496.25. Today, these downtown lots are worth millions.

When Indianapolis was first populated, settlers had to deal with panthers, wolves, wildcats, and an occasional bear. Those animals are long gone from Indianapolis. Deer were common and the meat was cheaper than beef or pork. Squirrels were so numerous they were a pest to farmers. Fish were of the best quality and in great abundance in the streams. Now, fish are much more sparse and when caught are not edible due to pollution.

In 1824, the legislature voted to move the state capital from Corydon to Indianapolis the following year. The move would have a profound effect on the future of both cities. A two-story brick building was built at the corner of Washington Street and Capitol Avenue to first serve as the State House.

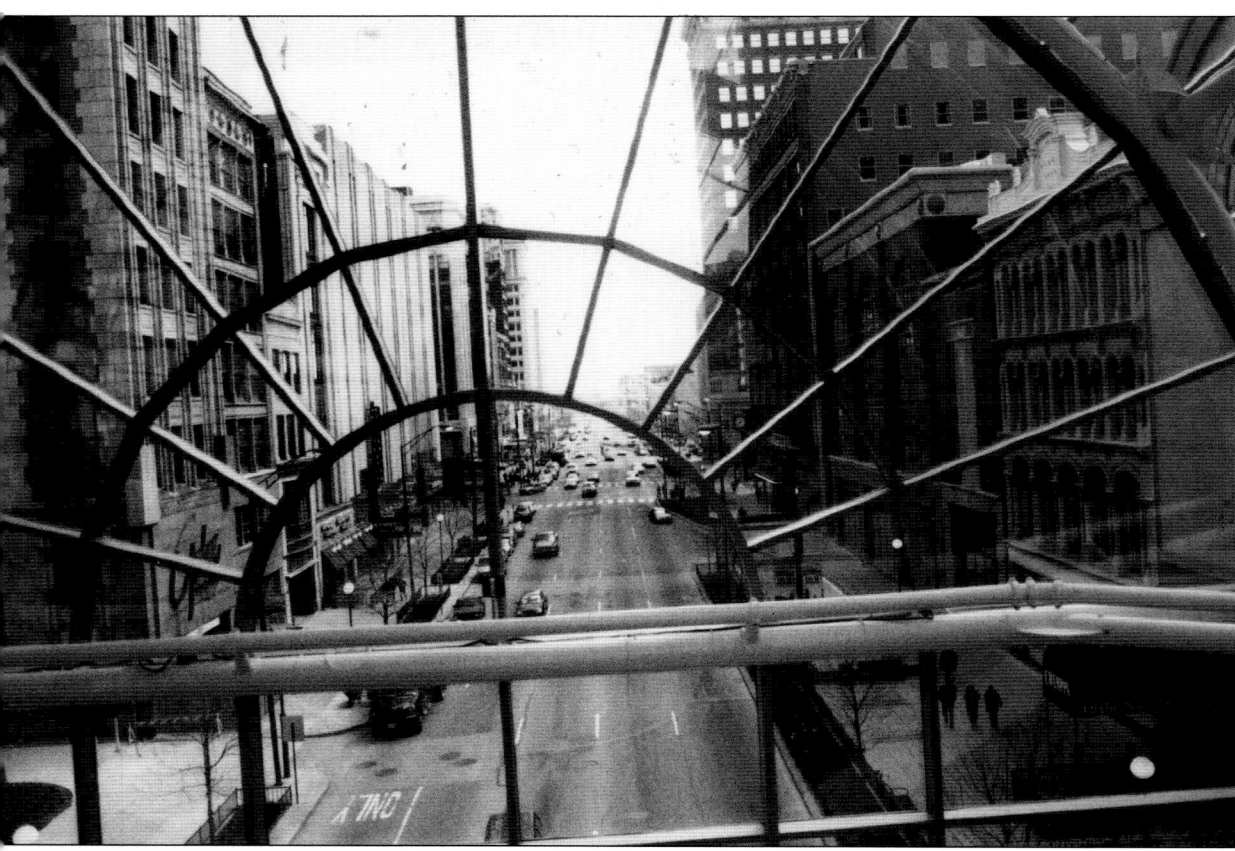

MAIN STREET. Washington Street, as seen through the Artsgarden, was also known as Main Street to the early citizens of the city. It was the first street completed in Indianapolis. Now, it is one of the busiest streets downtown.

Chapter 1
STREETS

Before 1900, the streets of Indianapolis were ruled by horses, mule cars, and streetcars. The mule streetcars took passengers around the city from the 1860s until the 1890s. Tracks were then laid on the major streets to carry the electric streetcars, which ran until the 1930s. After 1900, an interurban system was set up to take residents to outlying areas, such as Greenwood, Broad Ripple, and Wanamaker. Streetcars were replaced by electric buses for awhile until buses switched over to diesel engines. Today, a maze of expressways has replaced the interurban to carry people from outlying areas to and from Indianapolis. Nowadays, horses are only used by the Indianapolis Police Department and by vendors to carry visitors on a scenic carriage trip around downtown.

When Indianapolis was first formed, there were no roads. The terrain was rough and crowded with stumps. The streets in Indianapolis began as dirt paths for horses and wagons to travel over. The first paving came in 1837 when the federal government used broken stone to pave the National Road, which came through Indianapolis as Washington Street. In the 1850s, cobblestone streets came about in some areas. Paving streets using wooden blocks, bricks, concrete, and other materials began in the late 1800s.

The streets of Indianapolis have undergone some changes since the original plat was made in 1821. Most of the streets in Ralston's Plot ran east/west or north/south. The four diagonal streets emanating from the center of the square were Indiana Avenue, Massachusetts Avenue, Virginia Avenue, and Kentucky Avenue. Kentucky no longer reaches Washington Street because of the RCA Dome. Massachusetts Avenue and Indiana Avenue end a block shorter than originally platted due to building construction. Two other streets, North Carolina and South Carolina, were replaced by the railroads. Tennessee Avenue was renamed Capitol Avenue and Mississippi Street was changed to Senate Avenue in 1895. When the city began to grow to the north, First Street began at what is now 10th Street. Maple Road later became 38th Street. The State Fairgrounds was located around Delaware and 18th Streets before 1900 and later moved to 38th Street and Fall Creek Parkway. The area around Military Park became the campus of Indiana University Purdue University Indianapolis and many of those streets were lost.

Downtown Indianapolis also went through a transformation when the expressways were built around it. The city became much more accessible to people in the outlying area, so more moved to the suburbs to get away from the congestion of Marion County. In recent years, new housing and improvements to the downtown area have brought some of those residents back to inner city living. **STREETCARS.** Retail establishments lined East Washington Street from Meridian Street in 1900. Now, the Borders Bookstore sits on the southeast corner of Washington and Meridian Streets in the Barnes & Thornburg Building, which is listed on the National Register of Historic Places. On the northeast corner is the One North Meridian Building, which contains such businesses as the King Cole Restaurant, Dooley's Bagels, Bodner Group, and several law offices.

Streetcar. The electric streetcar, a.k.a. trolley car, ran on the streets of Indianapolis from the late 1800s until the 1930s. The cars usually seated 40 passengers. This postcard shows a summer trolley traveling along Illinois Street to 34th Street. Transfer stations were available in the downtown area for passengers wishing to switch from one trolley to another. The streetcar was replaced by electric bus service in the 1930s. Today, IndyGo's diesel powered buses take people around Indianapolis.

Washington Street. Historical markers honor Washington Street as part of the old National Road system that was the main east/west highway for the nation in the 1800s and the site where Abraham Lincoln spoke on February 11, 1861 on his way to Washington D.C. to take office. During the 1830s and 1840s, the road was very busy with horses, wagons, and stagecoaches until railroads were built. The street has gone from a two-way thoroughfare to a one-way heading west through the downtown area for better traffic flow. Horses have been replaced by vehicles with hundreds of horsepower.

ARTSGARDEN. Washington Street west from Meridian Street was a bustle of activity lined with retail stores as seen in this early postcard. Many individual stores are now gathered in Circle Center, which is on the south side of the street. A $12 million Artsgarden was built to span the intersection of Washington and Illinois Streets and connect Circle Center to Claypool Court. The Artsgarden hosts dances, theater performances, musicians, and other family programming. The glass-domed rotunda also provides a magnificent view of Washington Street.

CIRCLE CENTER MALL. Washington Street between Meridian and Illinois Streets contained several businesses in the late 1800s. L.S. Ayres used to be located at 33-37 West Washington Street in a building constructed in 1875. To the right of the Ayres building stood Vance Hunter & Company and the Occidental Building. To the left of Ayres was Charles Mayer & Company. Ayres moved to the end of the block in 1905. All of the buildings built before 1900 have been replaced by the Circle Center Mall. The façade of the L. Strauss building remains as a memory

of the history of the block. Champs Restaurant now sits where the Occidental Building was located. Parisian now occupies the corner opposite to where L.S. Ayres was once located.

MARKET STREET. In the early 1900s, Market Street between the Soldiers and Sailors Monument was busy with interurbans as the Traction Terminal, shown in this postcard, was located there. The rails of the interurbans have since been paved over

with bricks on Market Street. (Postcard courtesy of George Mitchell.)

MERIDIAN STREET. Meridian Street is the east/west dividing line in the city. Looking north from Maryland, before the Soldiers and Sailors Monument was built, Meridian Street was only interrupted by a park and a statue of Governor Morton at Monument Circle. A wholesale druggist and glass dealer was located at the corner of Maryland and Meridian Streets in the 1880s. Now Nordstrom, part of Circle Center, is located there. The statue of Governor Morton was moved next to the State House.

MARKET STREET. Before 1900, Market Street west of Pennsylvania Street contained mainly apartment buildings. Today, the street is flanked by businesses and banks, and the Soldiers and Sailors Monument interrupts passage to the State House. On the south side of Market Street, Union Federal and Revolution Wireless stand, while on the north side a Hilton Hotel is being built.

NORTH ILLINOIS STREET. Illinois Street was full of activity in the early 1900s just as it is today. Pedestrians in front of the Claypool Hotel at Washington Street had to watch out for the streetcars that ran the street as well as horses and wagons. Now they have to watch out for automobiles. The seven-story buildings of the past have been replaced by skyscrapers. An Old Navy store now sits where the Claypool Hotel was once located.

ILLINOIS STREET. The J.W. Bryan Pharmacy was located on Illinois Street across the street from Union Station before 1900. The Omni Severin Hotel now sits where the pharmacy was located. Across the street sits Pan Am Plaza, built when the Pan Am Games came to Indianapolis.

South Illinois Street. According to this postcard, the Hotel Edward and Majestic Theatre were located on Illinois Street south of Maryland in 1900. Now, a walkway stretches across Illinois Street from Circle Center Mall to a parking lot across the street. A Steak 'n Shake sits where Hotel Edward was once located.

PENNSYLVANIA STREET. Pennsylvania Street was a two-way street back in the 1920s and diagonal parking was allowed. Streetcar tracks also ran down the middle as seen in this postcard. On the northeast corner of Pennsylvania and Market Streets was Deschler's Cigar Store. The cigar store has been replaced by a modern office building that houses the National Bank of Indianapolis. Pennsylvania Street is now a one-way street heading south and cars are parallel parked along it.

Busy Corner. A couple of buildings at the intersection of Washington and Pennsylvania Streets seen in this 1900 postcard still exist today. Pennsylvania Street was renamed Nittany Lion Drive in March 2003 when the NCAA basketball championships were held in the city. Now a Panda Express sits on the northwest corner of the intersection with a Christian Science Reading Room and H&R Block next door to it. A parking lot has replaced several of the buildings to the north of those stores.

MASSACHUSETTS AVENUE. Massachusetts Avenue hasn't changed much in 100 years. The first building in a 1910 postcard on the corner of Delaware Street and Massachusetts was razed and is now a parking lot. The second building is now the Front Page Sports Bar & Grill. Stouts Shoes has been located in the third building since 1886. Now, next to Stouts is Bazbeaux Pizza. The five-story building is the Marrott Center, which was the Marrott Department Store. Further down the street is the arts district, featuring theaters, galleries, restaurants, and retail stores.

a larger shopping area. Streetcars used to run to Fountain Square. Those tracks have been paved over today.

FOUNTAIN SQUARE FOUNTAIN. Before 1900, the fountain in Fountain Square was a bit smaller than it is today. F.W. Rosebrock & Company had a grocery store in the square, which is located southeast from downtown on Virginia Avenue. The area has now become

FOUNTAIN SQUARE. Quaker Oats was painted on the side of the three-story building in this postcard of Fountain Square from around 1900. That building was replaced by a larger four-story building. The Fountain Square Theatre Building opened in 1928 and is now on the National Register of Historic Places.

PROSPECT STREET. Prospect Street cuts through Fountain Square on its way through the south part of the city. Businesses and homes still line the street.

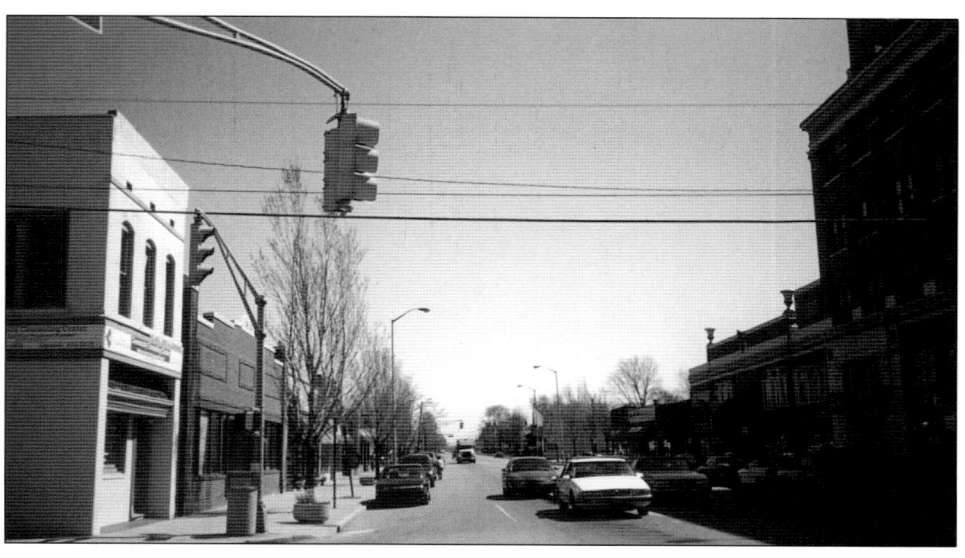

Chapter 2
GOVERNMENT

Indianapolis officially became a town in 1832. County commissioners, who controlled the city until then, declared the town incorporated and ordered an election. John Wilkins, Henry P. Colburn, John G. Brown, Samuel Henderson, and Samuel Merrill were elected as trustees. Trustees remained in charge of the city until a city government was adopted in 1847. Samuel Henderson became the first mayor in 1847. Today, the structure is quite different under Unigov, created in 1969 by the Indiana General Assembly. Under Unigov, Indianapolis became a consolidated city and most government services in Marion County and the city were fused together with a few exceptions. School districts remain independent as before, and police and fire departments continue their operations with little change. The cities of Beech Grove, Lawrence, Southport, and the town of Speedway were not included in Unigov. However, people living in those communities are still responsible for county taxes. In short, the governmental structure became more complicated than the system it replaced. A mayor-council structure runs the city and Marion County.

STATE HOUSE. The State Capitol was moved to Indianapolis in 1825 from Corydon. The general assembly met in a courthouse between 1825 and 1835 until the first State House was built. Built under the supervision of Governor Noble, Morris Morris, and Samuel Merril at a cost of $60,000, it featured a Greek design with an Italian Renaissance dome. In 1877, the building was sold for $250 to John Martin, who removed it by April 1, 1878 to make room for a new State House.

STATE HOUSE. The current State House was built in 1887-88 and cost more than $2 million. The original house consisted of a central dome and rotunda, flanked by four-story wings. It became overcrowded during the 20th century and was remodeled repeatedly. The State House went through an $11 million renovation in 1988 to return it to its original condition. Other state buildings were constructed west of the State House in the 1980s and 1990s.

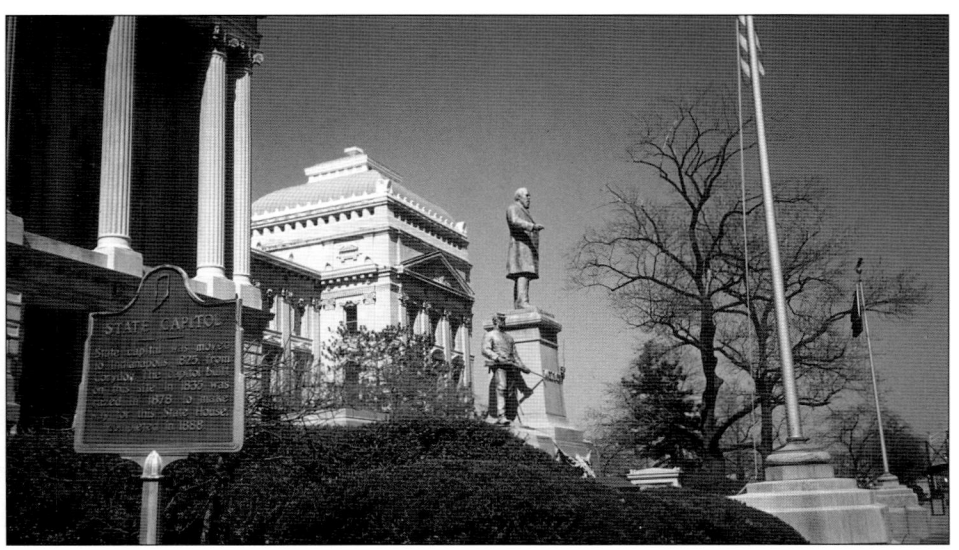

INDIANA WOMEN'S PRISON. The Indiana Reformatory Institution for Women and Girls, located between Michigan and New York Streets, was opened on October 8, 1873. It later became the Indiana Women's Prison. This first building was later razed. The Women's Prison now holds about 400 prisoners and is made up of many different buildings, including this administrative building. "We specialize in the special cases (pregnant women, etc.)," said Superintendent Dana Blank.

City Building. The city courts and police shared the same building before 1900, according to this early postcard. The police headquarters is now located next to the City-County Building, where the city courts are located.

COURT HOUSE. The Marion County Court House became a prominent structure in Indianapolis as seen in the early postcard below, when it was constructed in 1876 at a cost of $1.4 million. It was razed in the early 1960s when the modern 28-story City-County Building was completed.

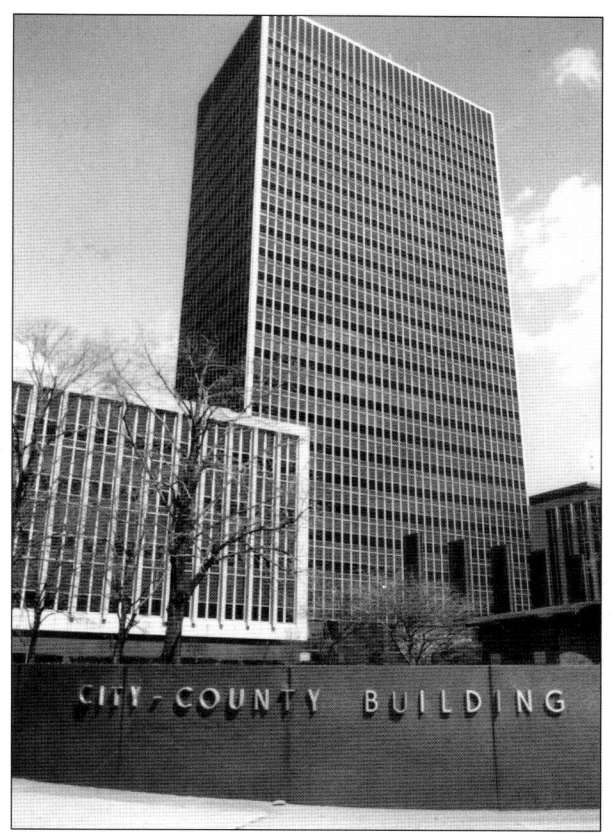

CITY HALL AND STATE MUSEUM. Before the City-County Building was constructed, county and city offices were in separate facilities. The Indianapolis City Hall was located at 202 North Alabama. Opened in 1910, the building featured neoclassical architecture, a popular style among public buildings at that time. When the city outgrew the building in the 1950s, city and county officials put their heads together and came up with a building to consolidate city and county offices in a single structure. The old city hall was turned over to the Indiana State Museum in 1966 and served the museum until 2002, when a new $105 million structure was opened in White River State Park. The new museum houses an IMAX theater and 72,000 square feet of exhibit space. The old city hall, which was listed on the National Register of Historic Places in 1974, now serves as a temporary headquarters for the Marion County Library, while its building is reconstructed.

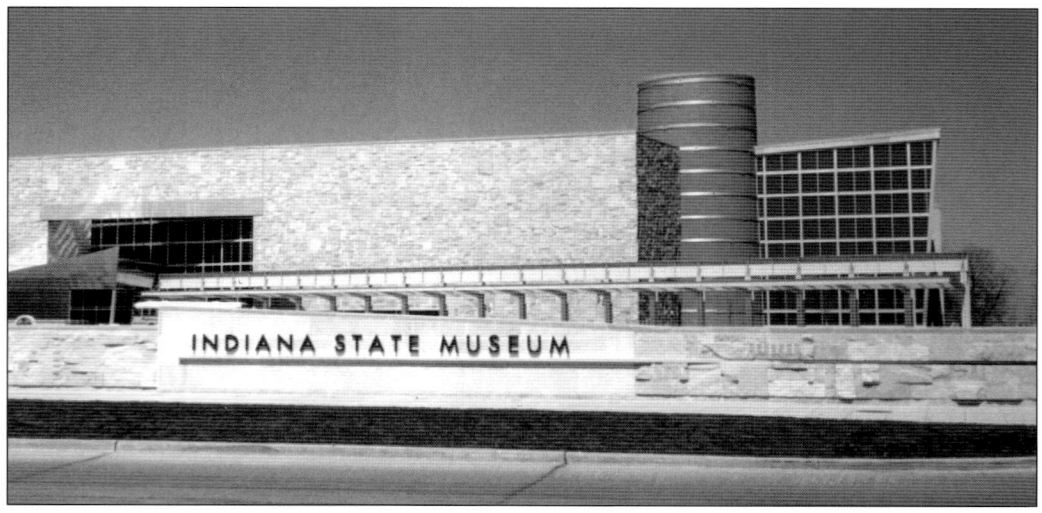

MARION COUNTY JAIL. The first Marion County Jail was a log cabin built on the northwest corner of the intersection of Market and Delaware. This postcard, below, shows the fourth Marion County Jail that was built in 1891. It was located on the east side of Alabama Street between Market and Washington Streets. The $150,000 jail was designed to hold 150 prisoners. By the 1930s, it became overcrowded, but a new building didn't come until 1965 with a $4 million price tag. The capacity of the jail increased to 778 by 1978.

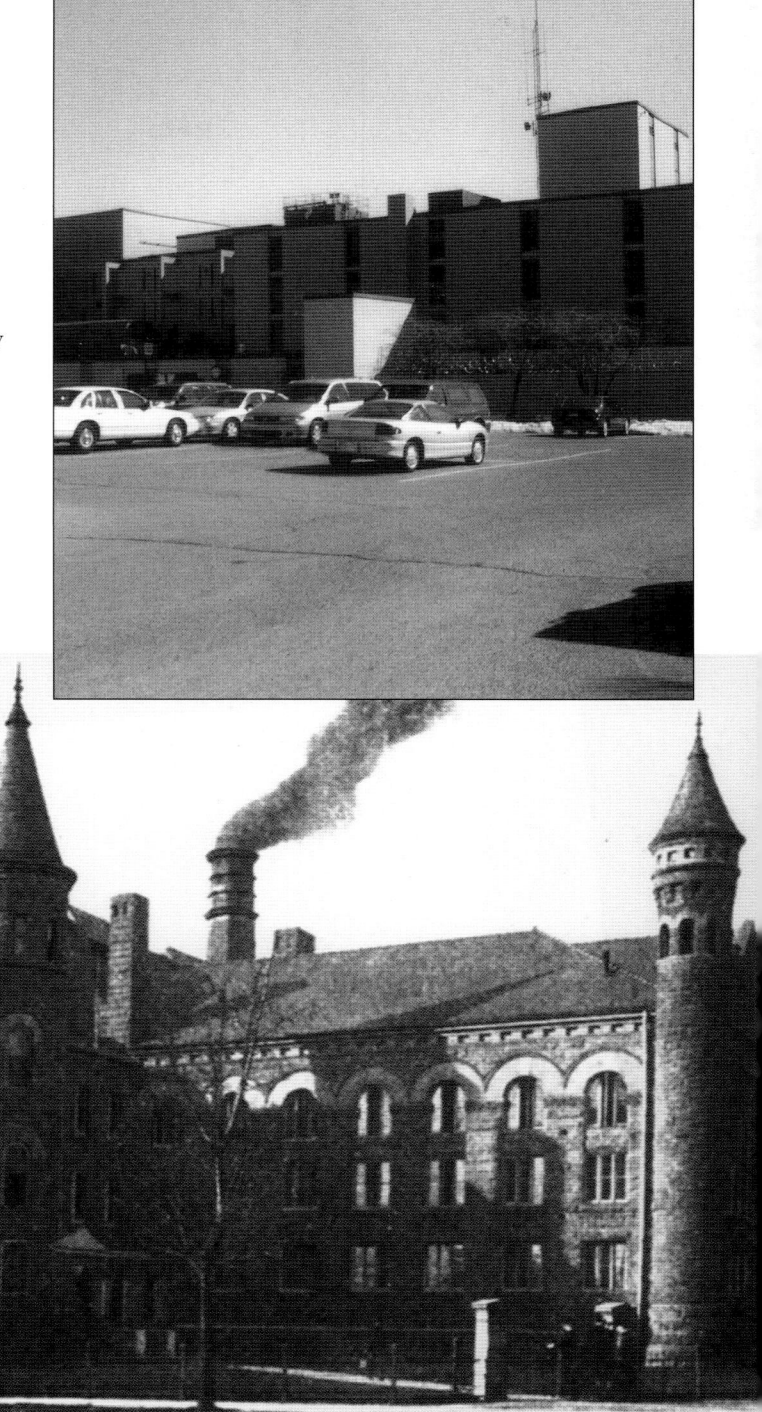

PUBLIC LIBRARY. The first public library and office of public schools was built in 1873 at the southwest corner of Pennsylvania Avenue and Michigan Street, which is now occupied by the World War Memorial. The present Marion County Public Library on St. Clair Street is getting a facelift and expansion and will be closed until 2006. Meanwhile, the old city hall building is being used by the library.

ENGINE COMPANY. Engine Company #11 was located on East Washington Street and firefighters used horses and wagons in the early days to haul their equipment. The building has since been restored and still exists today, but the houses next to the station are long gone.

FRIENDLESS WOMEN. The Indianapolis Home for Friendless Women was established in 1867 as a temporary shelter for Civil War solders' widows and orphans. It was located at Ninth and Tennessee Streets (now 18th Street and Capitol Avenue). Now it is known as the Indianapolis Retirement Home and serves 56 residents.

DEAF SCHOOL. The Indiana Deaf and Dumb Asylum was opened in 1850 at Washington and State Streets. That name lasted until 1907 when the legislature renamed it the Indiana State School for the Deaf. The Indiana School for the Deaf moved to its current location at 1200 East 42nd Street in 1911. Current enrollment is 321 students and the principal is Bob Kovatch.

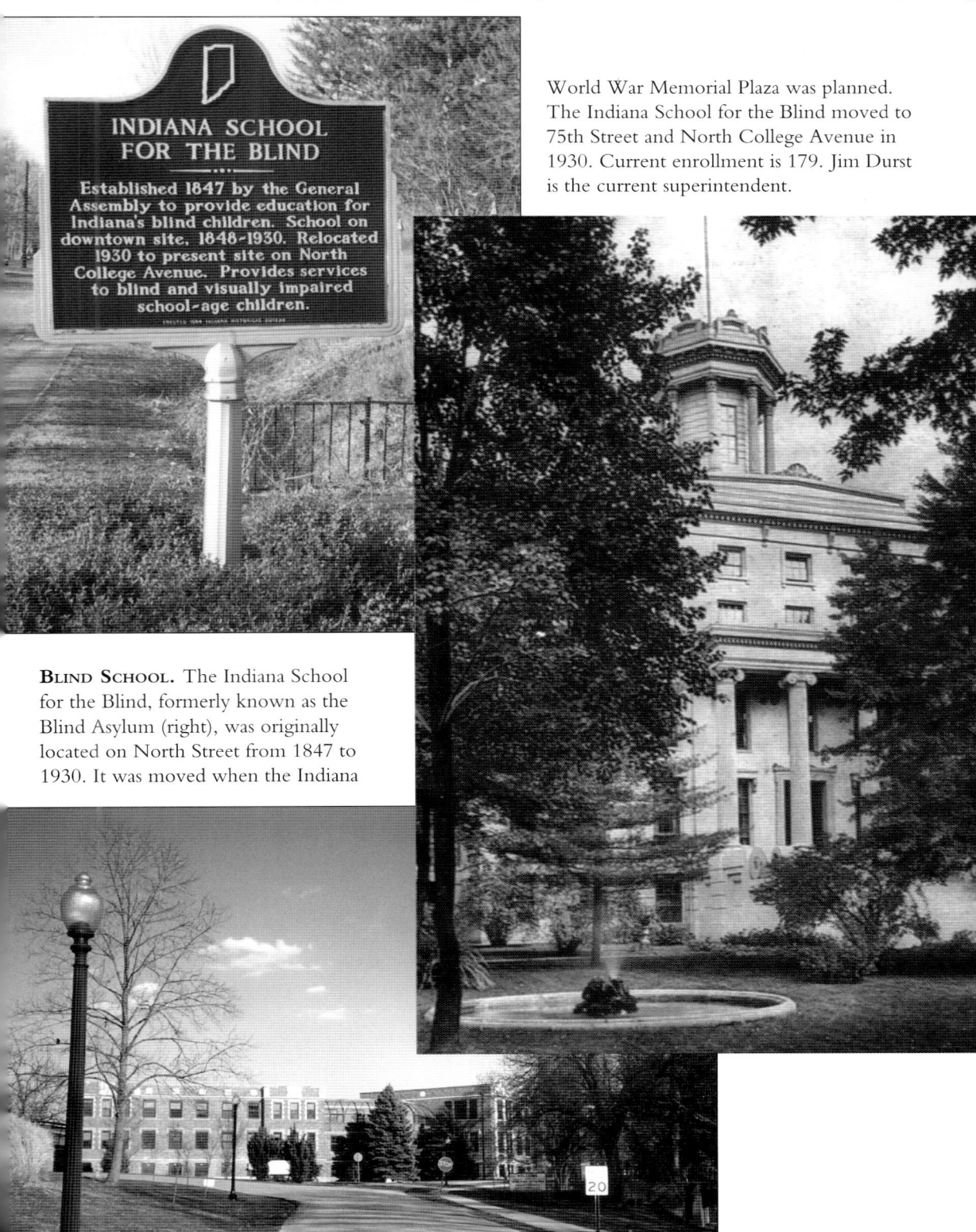

World War Memorial Plaza was planned. The Indiana School for the Blind moved to 75th Street and North College Avenue in 1930. Current enrollment is 179. Jim Durst is the current superintendent.

BLIND SCHOOL. The Indiana School for the Blind, formerly known as the Blind Asylum (right), was originally located on North Street from 1847 to 1930. It was moved when the Indiana

HIGH SCHOOL. Indianapolis' first high school, which was later called Shortridge, was located at Pennsylvania and Michigan Streets. The school was later replaced by the Federal Building. Shortridge is now a middle school located on North Meridian Street.

Chapter 3
BUSINESSES, BUILDINGS, AND BRIDGES

By 1822, business was beginning to take shape in Indianapolis. Taverns, grocery stores, and tailor shops were built. Blacksmiths, carpenters, bricklayers, doctors, and lawyers were in high demand. A newspaper, the *Gazette*, first appeared. It was printed in a log cabin at the corner of Maryland and Missouri Streets. Today, Indianapolis has thousands of businesses and several newspapers. "I think the two biggest challenges to business in Indianapolis are finding adequate funding for expansion and development and finding and retaining a quality workforce," said John S. Myrland, president of the Indianapolis Chamber of Commerce. "There are many programs to address both, but with the weak economy, inadequate government funding, and challenges to our public education systems, many businesses are still seeking answers and assistance."

Indianapolis began with log homes serving as residences and businesses. John McCormick ran the first Indianapolis tavern at his cabin. The log and framed homes and businesses soon gave way to more significant brick and limestone structures, some of which still exist today. Around 1900, the largest buildings were only a few stories tall. Many of them have been razed in favor of more significant skyscrapers in downtown Indianapolis.

When Indianapolis was first settled, there were no bridges to cross the creeks and White River. Ferries were used to cross the waterways. The first bridges in Indianapolis were constructed in the 1830s and were made of wood; some were covered. Those were replaced by steel and iron bridges. In 1899, a program was started to replace the bridges with permanent stone and concrete bridges. However, the flood of 1913 heavily damaged many of the bridges and some had to be completely replaced.

ENGLISH HOTEL. The English Hotel and Opera House was constructed on the northwest quadrant of Monument Circle from 1884-96 by William Hayden English, who was a Democratic vice-presidential candidate in 1880. English bought the Plymouth Church, renamed it English Hall, and used it as an auditorium for meetings and lectures. The hotel was demolished in 1948 and J.C. Penny built a modern structure, which is now called the Anthem Building and houses several business, such as Forum, FedEx, Sprint, and Fifth Third Bank.

MAJESTIC BUILDING. The Majestic Building was the first skyscraper in Indianapolis when it was built in 1896 at a cost of $350,000. The Indiana Gas Company was headquartered there until 1958. Today the Majestic houses numerous arts organizations and the Majestic Restaurant.

METROPOLITAN THEATRE. The Metropolitan Theatre opened in 1858 with 800 seats and was later renamed several times: Park, Lyceum, Strand, and Capitol. It was closed in 1935. The One North Capitol skyscraper now occupies the northeast corner of Washington Street and Capitol Avenue. The first theater in Indianapolis was actually a tavern. "The Jealous Lovers" and "Lord, What a Snow Storm in May and June" was presented at Carter's tavern on December 31, 1823. Nowadays, several theaters, big and small, serve the citizens of Indianapolis with various plays, concerts, shows, and the like.

MADAME WALKER THEATRE. The Madame Walker Theatre is named after Madame C.J. Walker, one of America's first African-American millionaires. First built as the home of Walker Manufacturing, the 950-seat theater was used for vaudeville shows and later as a movie theater. This postcard shows the theater before it underwent a $5 million restoration in 1988 to bring it back to its original condition. It now contains a museum and more than 100 events are held there each year. (Photo by William A. Rasdell.)

CIRCLE TOWER. The Franklin Insurance Company Building was located on the southeast corner of Monument Circle. The building was razed and replaced by the Circle Tower in 1928. The art deco–styled building was constructed by William P. Jungclas Company. The tower was the first to feature setback construction and stands 14 stories tall. It is occupied primarily by lawyers.

ATHLETIC CLUB. The Independent Athletic Club was built before 1900 and was located on Meridian Street. The club enjoyed prosperity until after World War I. Then its popularity dwindled due to anti-German sentiment. It was eventually turned into apartments and still exists today. The Indianapolis Athletic Club was incorporated in 1920 by a group of Indianapolis businessmen. The nine-story structure was completed in 1924. The athletic and social club has been faithful to the Amateur Athletic Union. Plans were made in 2003 to update the fitness facility and hotel rooms.

NORTH WESTERN CHRISTIAN UNIVERSITY. North Western Christian University was chartered in 1855 at College Avenue and Home (13th) Street on land provided by Ovid Butler. When the university moved to Irvington and the name was changed to Butler College, the Orphan's Asylum took over the old university building. The site was bulldozed when an expressway was built and a historical marker now identifies the site.

BUTLER UNIVERSITY. Butler College in Irvington became Butler University and moved to Fairview Park in 1928. Now the sprawling campus of 20 buildings has some 7,500 students and a full-time faculty of 245.

BATES HOUSE. The Bates House was located at the corner of Illinois and Washington Streets until 1903. President Abraham Lincoln spoke from the balcony on his way to being inaugurated president in 1861. He also spoke at the intersection of Washington and Missouri Streets and a historical marker is there to remember the occasion. Bates was torn down and replaced by the Claypool Hotel, which contained 450 guest rooms. The hotel was closed following a fire in 1967 and demolished two years later.

(right) **CLAYPOOL COURT.** Claypool Court and Embassy Suites Hotel replaced the Claypool Hotel. Now an Old Navy store occupies the court as well as an Off-Track Betting parlor.

PRICE HAMMOND BLOCK. The Price Hammond Block building was erected in 1874 on the northeast corner of Massachusetts Avenue and New York Street. The building has stood the test of time and is now occupied by the law firm of Price, Jackson, Waicukauski & Mellowitz.

TOMLINSON HALL. Tomlinson Hall, shown in this early postcard, was built in 1883 after druggist Stephen D. Tomlinson died and stipulated it be built. The hall had businesses and markets on the first floor. The upper floor contained a large theater and stage. The hall was destroyed by fire in 1958. The City Market has since expanded into the space and a park accommodates lunch time workers from the City-County Building across the street.

HUBBARD BLOCK. The building on the southwest corner of Meridian and Washington Streets was first known as the Hubbard Block. Before 1900, businesses located in the building included Merchants National Bank and American Express. The building to the right of the Hubbard Block was called the Iron Block and contained Eagle Clothing and Turpin & Company, 5, 10 & 25 cents. L.S. Ayres purchased the Hubbard Block and built a new eight-story building in 1905. The building is now occupied by Parisian and part of Circle Center. The Iron Block building was razed.

VANCE BLOCK. Indiana Trust was first located at the corner of Pennsylvania Street and Virginia Avenue in a building known as the Vance Block. The building was razed and the area is now Jefferson Plaza.

NEWTON CLAYPOOL. The Newton Claypool Building was located at the corner of Pennsylvania and Ohio Streets. The building was razed in favor of a skyscraper and now houses First Indiana Bank.

COLUMBIA CLUB. Distinguished citizens of Indianapolis first formed the Columbia Club in 1889 and it was incorporated the following year. The club was located at 78 Monument Circle before settling in to its current residence at 121 Monument Circle in 1925. The building was listed on the National Register of Historic Places in 1983. Scores of dignitaries have visited or stayed at the club, including every Republican president. Today, the club has a membership of 2,700. In 2002, the club began a $3.5 million renovation of the building to bring it up to modern standards.

CHAMBER OF COMMERCE. The Board of Trade promoted economic growth in Indianapolis in the second half of the 1800s. The board was replaced by the Chamber of Commerce, which was founded by Col. Eli Lilly and other business leaders in 1890. An eight-story building was constructed in 1893. The chamber moved into its current headquarters at 320 North Meridian in 1926. The organization has accomplished much in the century of its existence, such as redevelopment, slum clearance, and Unigov. Today, the Greater Indianapolis Chamber of Commerce has some 3,000 members, a staff of 30, and a budget of $3.5 million. The chamber and the government in Indianapolis have traditionally worked very closely together to promote economic opportunity, which improves the quality of life for all citizens. "Basically, a healthy combination of government incentives, business investment, and philanthropic and not-for-profit cooperation have helped our city to address the many challenges in today's economy," said President John S. Myrland. "This 'public-private' partnership has proven to be successful in the past and will continue, I feel, into the future."

with marble floors, Russian white oak, and a carillon of 54 bells, was listed on the National Register of Historic Places in 1983 and is open daily for tours. The banquet and meeting facilities can accommodate up to 2,500 people and the theater seats 1,200. It also has a magnificent ballroom.

SCOTTISH RITE. The Scottish Rite was located on South Pennsylvania Avenue next to the Majestic Building until building a majestic cathedral at 650 North Meridian Street in 1929 at a cost of $2.5 million. Architect George F. Schreiber gave the building a Tudor design with Gothic ornamentation. The marvelous building

IMPERIAL HOTEL. The Imperial Hotel was located across the street from the State House on Capitol Avenue and was used by politicians. A modern eight-story office building has replaced the hotel. A Hallmark store sits on the bottom floor.

ARMORY. An Armory was located at the corner of 16th and Senate back before 1900, according to an early postcard. That area has been taken over by Methodist Hospital. The state then built Tyndall Armory at 711 North Pennsylvania Street in 1926 at a cost of $425,000. Another armory was built on the south side of the city. The 276th Military Intelligence Company and 38th Infantry Division ("Avengers of Bataan") of the Indiana National Guard call Tyndall home. Over the years, the armory has hosted boxing and wrestling matches for the public.

METHODIST HOSPITAL. Methodist Hospital opened in 1908 with 65 beds at the corner of Capitol Avenue and Tinker Street (now 16th Street). The site was used as a baseball park for the Indianapolis Indians prior to that. At first, the hospital looked like this early postcard. The city grew and the hospital was demolished to make room for a much more modern facility, which is now two blocks in length and has 775 beds. The first open heart surgery in Indiana was performed here in 1965. In 1997, Methodist, Indiana University, and Riley Hospitals united to form Clarian Health. A "people mover" began operating in 2003 to connect the facilities.

M. E. Hospital. Indianapolis, Ind.

CITY HOSPITAL. Indianapolis opened a city hospital in 1866 at First Avenue (now 16th Street) and Indiana Avenue. The 75-bed charity hospital soon became overcrowded and underfunded. In the 1870s and 1880s, many improvements were made under the administration of William Niles Wishard Sr. In 1975, the hospital was renamed for the administrator. Wishard Memorial Hospital then allowed Indiana University School of Medicine to manage the facility. The hospital now has 618 beds and still treats the most indigent in the county as well as trauma and burn patients. It has the busiest emergency care center in the state.

TRACTION TERMINAL. Market Street was a very busy place in the early 1900s with the Traction Terminal across the street from the State House as seen in this early postcard, below. The rails used by the streetcars and interurbans have been paved over by a brick street and high-rise office buildings have replaced smaller buildings of the past. The Indiana State Teachers Association now occupies the space where the Traction Terminal was once located.

QUARTER-MASTER'S HEADQUARTERS AND TRUCK TRAIN, FT. BENJAMIN HARRISON, INDIANA

FORT HARRISON. Fort Benjamin Harrison was established in 1904 and was used as a training facility and pay center for the U.S. Army for some 90 years. The fort was ordered closed in the early 1990s, but the Defense Finance and Accounting Center and the Army Reserve still remain. Some of the old army facilities have been sold to civilian concerns, such as businesses and retailers. The quarter-master's headquarters in this early postcard has been taken over by civilian companies: Concept Marketing Group, Omni Chem, and Primerica. Cars now park where trucks used to line up to be loaded.

KINNICK'S. Before 1900, Geo. H. Kinnick's Dry Goods and Millinery was located at 945 Massachusetts Avenue as seen in this early postcard. That location is now under tons of concrete as Massachusetts Avenue is interrupted by an expressway downtown known as the Spaghetti Bowl.

MANNFELD TAILOR. George Mannfeld Tailor was located at 17 East Washington before 1900. The staff posed for this picture. The building is long gone and was replaced by a modern office building that is now vacant. A mural was painted on the side of the building.

BLOEMKER. E.F. Bloemker used to operate a grocery and meat store at 1202 East New York Street around 1900. The store is long gone and so is the house. It was replaced by another home, which has since been boarded up.

FLETCHER BANK. The Fletcher Bank was located at 30 East Washington Street. The building was razed and Fletcher Bank no longer exists. The Symphony Center Building is now located at 32 East Washington Street.

WHEN BUILDING. The When Building was a men's and boy's clothing store located on Pennsylvania Street between Washington and Market Streets. When John T. Brush was putting in the store, he hung a sign that read, "When?" The name caught on. It was later renamed the Ober Building and razed in 1995. A parking garage has replaced the When Building at 36 North Pennsylvania Street.

ORPHAN'S HOME. The German Protestant Orphan's Home, located at 1404 South State Street, was built in 1865 and housed orphans from the Civil War. The home now belongs to RTC Resource, Inc. and is used as a residential treatment center for adolescents. The first floor of the old home was renovated to house the adolescents.

Chapter 4
HOMES AND DIVISIONS

The first homes in Indianapolis were log cabins built by early settlers, such as John Nowland, John McCormick, George Pogue, John Shunk, and Isaac Wilson. The small log cabins were soon replaced by frame and brick homes. After the capital was moved to Indianapolis, more substantial homes were built. Residential areas expanded north and east from the mile square. Citizens settled in Lockerbie Square and Fletcher Place. Prosperous citizens moved to the subdivisions of Irvington and Woodruff Place. Empire houses and mansions began to appear.

After a century of growth, Marion County was filled with residents and businesses and the small villages around the city became cities themselves like Greenwood and Carmel. Today, the counties surrounding Marion County are growing rapidly as citizens continue to move outward from Indianapolis.

LOCKERBIE SQUARE. People started moving into Lockerbie Square in the 1830s. Indiana poet James Whitcomb Riley lived at 528 Lockerbie Street and his home is now a museum. The area was put on the National Register of Historic Places in 1973. The cobblestone street of yesteryear remains today.

English Tudor country home from 1919 to 1945 at 101 East 27th Street. The mansion is now located on North Meridian Street.

GOVERNOR'S MANSION. The Governor's Mansion first stood in the center of Indianapolis at the Governor's Circle, now Monument Circle, from 1827–1839. The governor lived in an

HENDRICKS' HOME. The home of Thomas A. Hendricks, former governor of Indiana and vice president of the United States, was located at 81 North Tennessee (now Capitol Avenue). He died nine months after he became vice president under Grover Cleveland at his home. A monument was dedicated to him on July 1, 1890. The site is now a parking lot.

SAFECO. Before 1900, homes lined the west side of Meridian Street north of Michigan Street. The Safeco Insurance Building now occupies the 500 block of Meridian Street.

SHIEL'S RESIDENCE. R.R. Shiel lived on North Meridian Street before 1900. Businesses have since taken over the area of 15th and North Meridian and the site of his home is now a parking lot.

MCKEE'S HOME. The residence of Robert S. McKee was located at 418 North Tennessee (now Capitol Avenue). He was the president of McKee & Branham Shoe Company. A parking lot for the American United Life Insurance Company has replaced the McKee home on Capitol Avenue.

OLD NORTHSIDE. The Old Northside historical marker now sits where the home of L.S. Ayres once sat. The marker reads, "Vibrant historic district was home to many social, political, commercial and industrial leaders of Indianapolis during last half of nineteenth through early twentieth centuries. Revitalization of Old Northside is part of national historic preservation movement. Listed in National Register of Historic Places, 1978."

L.S. AYRES' MANSION. The home of Lyman S. Ayres, founder of L.S. Ayres, was located just south of former President Benjamin Harrison on North Delaware Street. The former property of L.S. Ayres is now part of the I-65 Expressway. Now the only people who occupy the former property are the homeless who sometimes sleep under the rumbling highway.

VAN CAMP'S RESIDENCE. The residence of Courtland Van Camp was located at 714 North Delaware. He was the president of Van Camp Hardware. The John Morton–Finney Education Center now occupies the former site of the Van Camp home.

CHILDREN'S MUSEUM. The Children's Museum, first established in the Carey mansion at 1150 North Meridian Street, moved to the Parry mansion as seen in this postcard at 3010 North Meridian in 1946. The mansion was razed in 1973 to make room for a larger facility. The present Children's Museum was completed in 1976. Now a dinosaur exhibit, called Dinosphere, is being constructed at the site and will be open in 2004. The museum has become the largest children's museum in the United States and had nearly 1 million visitors in 2002.

CHILDREN'S MUSEUM OF INDIANAPOLIS (INDIANA). 3010 NORTH MERIDIAN STREET

FLETCHER AND FAHNLEY. Allen M. Fletcher owned this home at 250 North Meridian Street. He was president of several companies including the Gas Light & Coke Company. Frederick Fahnley, who owned a wholesale millinery, had a home at 200 North Meridian Street.

SBC. SBC now occupies the 200 block of North Meridian Street where homes belonging to A.M. Fletcher and Frederick Fahnley once stood before 1900.

MORRIS' HOME. Thomas A. Morris, a general from the Civil War, lived at 100 Central Avenue. Businesses have since taken over the area and Ropkey Graphics operates a building at the site of the former home.

Meyer's Residence. Charles Meyer, owner of a cigar and dry goods store, owned a home at 323 North Delaware. Businesses have taken over the 300 block of North Delaware and 323 is now the Brown & Hastings law office.

WOODRUFF PLACE. James O. Woodruff built one of the first subdivisions in the country in Indianapolis in the 1870s on the east side of the young city. The affluent property owners of Woodruff Place successfully petitioned the city to incorporate as a town. However, Indianapolis began attempts to annex the town in 1890, but was not successful until 1962. About that time, Woodruff's home was torn down. Woodruff Place was added to the National Register of Historic Places in 1972. Today, 248 homes and apartment buildings occupy the subdivision. The old town hall building at Woodruff Place still exists today and is used as a community center by the residents of the four-street subdivision.

Delaware Street. Delaware Street north of Home Avenue (now 13th Street) used to be lined with single family homes as seen in this pre-1900 photo. Now apartments and businesses have replaced some of those homes.

McGowan's Home. Hugh J. McGowan built a home on the corner of Delaware from Home Avenue (now 13th Street). He was an electric railway entrepreneur, who established the Indianapolis Traction and Terminal Company in 1902. The Knights of Columbus bought the home after his passing and eventually tore it down to make room for a larger building.

BROAD RIPPLE. Broad Ripple began as two separate communities alongside the Central Canal in 1837. The two merged in 1884 to become one incorporated area. According to this early postcard, streetcars traveled down College Avenue to bring Indianapolis residents to the area around 1900 and it became a favorite summertime retreat complete with swimming and boating. The White City Amusement Park was built there in 1906, but it burned in 1908. Indianapolis annexed the area in 1922. The area has become a favorite gathering place for students from nearby Butler University.

Chapter 5
MONUMENTS, PARKS, AND OTHERS

Indianapolis stands second only to Washington D.C. in the number of monuments constructed throughout the city to honor its citizens, public servants, and military members. It has monuments to honor the military in every war this country has fought.

When Indianapolis was first planned, parks were not considered as part of the formula. In 1864, Military Park and University Square became the first parks. Parks were slow to develop until the city hired George E. Kessler in 1908 and new park laws were passed. The park system has grown over the years to provide the citizens of the city with recreation centers, pools, golf courses, and other amenities. Today, Indy Parks operates 149 parks in Marion County.

SOLDIERS AND SAILORS MONUMENT. The Soldiers and Sailors Monument was built from 1888 to 1901. When completed, it became the tallest structure in Indianapolis as seen in this early postcard. Designed by Bruno Schmitz of Germany, the monument was built to honor Civil War veterans. It instantly became the most popular tourist attraction in the city. Now it is decorated every November to serve the public as the "World's Tallest Christmas Tree." It was renovated in the 1990s to bring it back to its original state.

WORLD WAR MEMORIAL. Work on the World War Memorial began in 1927 and Gen. John J. Pershing laid the cornerstone on July 4 of that year. It took until 1965 before the structure was completed inside. The memorial was built to honor members of the military from Indiana. The Memorial Plaza was added to the National Register of Historic Places in 1989. It plays an important part in honoring the military during celebrations held on the Fourth of July, Veterans Day, and Memorial Day. The World War II Memorial was dedicated on May 22, 1998 and honors Indiana residents who fought in the conflict. It was designed by architect Patrick Brunner.

KOREAN WAR AND VIETNAM MEMORIAL. On May 24, 1996, two memorials were dedicated in Memorial Plaza to honor those who served in the Korean and Vietnam Wars. Both monuments came from architect Patrick Brunner.

BROAD RIPPLE PARK. In early 1900s, Broad Ripple Park contained the carousel shown in this postcard. The carousel was moved to the Children's Museum in 1970 and restored to its original condition. The park has undergone extensive changes in 100 years and a plaque says the park was "acquired for the people" in 1946.

A 27011 View in Broad Ripple Park, Indianapolis, Ind.

Shelter House at Brookside Par[k]
Indianapolis, Ind.

BROOKSIDE PARK. In early 1900, the shelter house in this early postcard was one of the biggest attractions in Brookside Park. Then in 1928, the Brookside Park Community Building was built by Harrison & Turnock Architects for the affluent area of the city at the time. The building is used by some 80,000 people a year and contains a full-size basketball court. The Capitol Improvement Board has approved expenditures of $385,000 to restore the balcony of the building. The 110-acre park now has a swimming pool, tennis courts, baseball diamonds, playgrounds, and a Frisbee course instead of a golf course, which it had for a long time.

SPADES PARK. Spades Park sits next to Brookside Park and used to contain a band shell according to this early postcard. The park also hosted a lantern festival a century ago and people around it are trying to revive the tradition. The park today contains a baseball backstop, a shelter, and picnic tables.

RIVERSIDE PARK. Riverside Park came about in the early 1900s and featured boating, swimming, picnicking, and golfing, some of which is shown in this early postcard. Steamboat cruises were also an attraction at the park as was a roller skating rink. In 1903, an amusement park was built there and included a roller coaster, Ferris wheel, and other attractions. Today, many of those attractions are long gone, but certain attractions remain, including a golf course, walking trails, and the Wilbur Shaw Memorial Hill, which annually hosts the Soap Box Derby.

BEAR PIT. The Bear Pit at Riverside Park was about the closest thing Indianapolis had to a zoo in the early 1900s. Indianapolis didn't get a zoo until 1964. To find the Bear Pit today, you need a metal detector. It's buried deep inside a small forest that has been allowed to grow around it. The forest is surrounded now by Riverside Golf Course.

The Bear Pit, Riverside Park, Indianapolis, Ind.

Entrance to Garfield Park, Indianapolis, Ind

GARFIELD PARK. Garfield Park was first called Southern Park when it came about in the 1870s. Before then the area was a harness racing track. After President James A. Garfield was assassinated in 1881, the park was renamed in his honor. A sunken garden was created at the park and remains today as one of the prettiest parts of the park. A memorial of Maj. Gen. Henry W. Lawton stands in the park to honor the Civil War veteran.

MILITARY PARK. Military Park was created in 1822 and is the oldest park in the city. A huge fountain was once a highlight of the park, as seen in the below postcard. The 14-acre park is located at the corner of West and New York Streets and was known as Camp Sullivan for awhile. The only structure left in Military Park today is this shelter house (above). The park is still used extensively for many events in the downtown area.

CROWN HILL CEMETERY. Crown Hill was much smaller when the above photo was taken in the 1800s. The cemetery contains many famous Hoosiers, such as President Benjamin Harrison, poet James Whitcomb Riley, 3 U.S. vice presidents, 10 Indiana governors, 14 mayors, and dozens of generals from the Civil War. The Heroes of Public Safety was dedicated on September 14, 2002 to honor firefighters, police, and others involved in public safety in Indiana who have perished.

INDIANAPOLIS INDIANS. In the early 1900s, the Indianapolis Indians played in Washington Stadium, located near the site of the current Indianapolis Zoo. Then in 1931, the Tribe began playing in Perry Stadium (above), later known as Victory Field and Bush Stadium. In 1995, the Indians moved into a new facility called Victory Field in downtown Indianapolis, not far from where Washington Park was located. (Washington Park photo courtesy of the Bass Photo Company Collection, Indiana Historical Society)

INDIANAPOLIS INTERNATIONAL AIRPORT. The Indianapolis Municipal Airport came about in the 1930s and was much like this postcard from those days. In 1944, it was renamed Weir Cook Municipal Airport in honor of H. Weir Cook, a World War II fighter ace who died in a plane crash during the war. Then in 1976, the airport was upgraded to an international airport and was renamed again. Major users of the airport include Federal Express, the U.S. Postal Service, United Airlines, and American Trans Air.

CHRIST CHURCH CATHEDRAL. The Gothic-style church was built in 1859 on Monument Circle at a cost of $32,438. A new spire was added in 1870. The spire was taller than surrounding buildings, according to this early postcard. It was placed on the National Register of Historic Places in 1973. The first church in Indianapolis was Presbyterian and was built in 1823. The one-story building was erected on Pennsylvania Street and also served as a school. The church, which is the last of five churches which once occupied Monument Circle, continues to serve the community and has a membership around 750.

Bibliography

Barrows, Robert G. and Bodenhamer, David J. *The Encyclopedia of Indianapolis*. Indianapolis, Indiana: Indiana University Press, 1994.
Holloway, W.R. *Indianapolis*. Indianapolis Journal Print, 1870.
Hyman, Max R. *Centennial History of Indianapolis,* Indianapolis, Indiana. 1920.
McDonald, John P. *Lost Indianapolis*, Chicago, Illinois: Arcadia Publishing, 2002.
Shaw, Bill. *Indianapolis Monthly*, March 2003, pp. 36-46.
The Indianapolis Star

Websites

www.assr-indy.org (Ancient Accepted Scottish Rite)
www.butler.edu (Butler University)
www.childrensmuseum.org (The Children's Museum of Indianapolis)
www.clarian.com (Methodist Hospital)
www.indychamber.com (Greater Indianapolis Chamber of Commerce)
www.indyrad.iupui.edu (Wishard Memorial Hospital)
www.indy.gov (Government in Indianapolis)
www.indychamber.com (Greater Indianapolis Chamber of Commerce)
www.indy.org